Promises *for the* Soul, Words *from the* Heart, AND Food *for* Thought

DEBRA LEWIS

WESTBOW
PRESS®
A DIVISION OF THOMAS NELSON
& ZONDERVAN

Copyright © 2016 Debra Lewis.

All rights reserved. No part of this book may be used or reproduced by any means, graphic, electronic, or mechanical, including photocopying, recording, taping or by any information storage retrieval system without the written permission of the author except in the case of brief quotations embodied in critical articles and reviews.

Scripture taken from the King James Version of the Bible.

WestBow Press books may be ordered through booksellers or by contacting:

WestBow Press
A Division of Thomas Nelson & Zondervan
1663 Liberty Drive
Bloomington, IN 47403
www.westbowpress.com
1 (866) 928-1240

Because of the dynamic nature of the Internet, any web addresses or links contained in this book may have changed since publication and may no longer be valid. The views expressed in this work are solely those of the author and do not necessarily reflect the views of the publisher, and the publisher hereby disclaims any responsibility for them.

Any people depicted in stock imagery provided by Thinkstock are models, and such images are being used for illustrative purposes only. Certain stock imagery © Thinkstock.

ISBN: 978-1-5127-4193-3 (sc)
ISBN: 978-1-5127-4194-0 (e)

Library of Congress Control Number: 2016907618

Print information available on the last page.

WestBow Press rev. date: 05/06/2016

Contents

1 Corinthians 13:13 .. 1
Love, Fireflies, and Springsteen ... 2
Chicken Spaghetti ... 3
Matthew 5:3–5 ... 4
A Coke and a Smile ... 5
Broccoli-Cheese Soup ... 6
Titus 3:1–2 ... 7
Survival of the American Spirit ... 8
Cheese-Chicken-and-Rice Casserole 9
Psalm 28:14 ... 10
Six Stars in the Window ... 11
Ruth's Squash Casserole ... 12
Matthew 5:43–48 ... 13
Living in the Sixties .. 14
Cabbage-Patch Stew .. 15
John 15:11 .. 16
Her Life .. 17
Sweet Potato Casserole ... 18
John 9:4–5 .. 19
His Life ... 20
Peach Cobbler .. 21
John 15:9–10 .. 22
Sixty Years ... 23
Swedish Pineapple Cake ... 24
2 Corinthians 8:21–22 ... 25
Birthday Boy .. 26
Chocolate Halfway Cookie Cake .. 27
John 15:8 .. 28

Triplets	29
Peanut Butter Crisp	30
John 11:25–27	31
An Angel Watching Over Me	32
Uncooked Banana Pudding	33
1 Timothy 6:6, 6:11	34
The Gentle Man	35
Hash Brown Casserole	36
Romans 12:11–12	37
All Your Heart	38
Millionaire Pie	39
Colossians 3:14–15	40
The Special Mom	41
Fruit Salad	42
Psalm 36:10	43
The Story of Stacy and Aaron	44
Holiday Punch	45
John 16:33	46
609 Greenwood	47
Vegetable Casserole	48
John 3:16, 6:40	49
Sunrise Spin	50
Green Bean Casserole	51
John 5:24	52
My Little Girl	53
Peanut Butter Fudge	54
John 20:31	55
My Son	56
Strawberry Bread	57

And now abide faith, hope, love, these three; but the greatest of these is love.

—1 Corinthians 13:13

Love, Fireflies, and Springsteen

A walk in the park on a summer night—
We laughed and talked and watched the fireflies light.
Into the darkness we watched them glow;
That's when our love started and began to grow.

We were both so young and looking for love;
We were given a gift that came from above.
Two lonely souls looking for direction,
Awaiting and wanting some kind of connection.

We walked hand in hand and became husband and wife;
Through trials and tribulations, we worked hard for a good life.
Many years married and our children grown,
We still dance to Springsteen at night in our home.

So, my love, I still look at you with love in my eyes;
My heart jumps for joy and holds love inside.
I thank God for you every time I kneel down and pray.
I will love you every second, every hour, every day.

Chicken Spaghetti

2 pounds chicken breast
2 cans cream of mushroom soup
1 egg
1 can chicken broth
1 pound cheddar cheese
1 package spaghetti, cooked and drained

Cook chicken until done.

Cut up cooked chicken and place in large baking dish with mushroom soup, egg, chicken broth, and cheddar cheese.

Cook spaghetti until tender; mix well with other ingredients.

Bake at 350 degrees F for approximately 30 minutes; top should be golden brown when done.

Blessed are the poor in spirit, for theirs is the kingdom of heaven.

Blessed are those who mourn, for they shall be comforted.

Blessed are the meek, for they shall inherit the earth.

—Matthew 5:3–5

A Coke and a Smile

Many years ago, in a not-so-far-away land,
A young man named Ronnie played in a band.
He sang on stage and played his guitar;
He was making extra money and working really hard.

He worked full-time in the Ferris school district,
But on Saturday nights, his guitar was his instrument.
He sang the songs so pure and sweet,
Everyone in the club would stand to their feet.

Now, Ronnie was the type who played with his heart and soul,
He loved what he did but was somehow alone.
But one night a girl named Sherry walked in the door,
He knew at that moment he was alone no more.

Now, Sherry was a beauty, but at that time a little sad,
She needed someone to hold her and take her by the hand.
Ronnie, being a gentleman, asked her for a Coke,
And from that moment on, that was all she wrote.

Soul mates they are and married for many years,
A grandchild visiting is what makes them cheer.
They still look at each other with love in their eyes,
And still go out and have a Coke every once in a while.

Broccoli-Cheese Soup

10 ounces frozen chopped broccoli
2 ounces angel hair pasta, broken into small pieces
1/4 cup butter
1 tablespoon flour
1 cup water
3/4 cup milk
1/8 teaspoon pepper
6 ounces Velveeta cheese, cubed
1/2 cup sour cream

Cook broccoli and pasta according to package directions for each; drain.

In large saucepan, melt butter; stir in flour until smooth. Gradually stir in water, milk, and pepper until blended.

Bring mixture to a boil; cook and stir for 2 minutes, or until thickened. Reduce heat; stir in cubed cheese until melted. Stir in broccoli, pasta, and sour cream. Heat through; do not boil.

Remind them to be subject to rulers and authorities to obey, to be ready for every good work.
To speak evil of no one, to be peaceable, gentle, showing all humility to all men.

—Titus 3:1–2

Survival of the American Spirit

Do you ever sit and wonder why life has become so hard?
Families go hungry, and hatred lives in people's hearts.
The loss of jobs and the unemployment rate so high,
Relationships falling apart, and all you can do is cry.

You live paycheck to paycheck, hoping to make ends meet,
Praying that gas won't go up, just to get through the week.
You're living life on a wing and a prayer,
Trying to keep your heart pure and know God is there.

What's happened to our country? I wish I knew.
Maybe it was taking prayer out of our schools.
Was it outsourcing jobs to send overseas?
We need a reason to make us believe.

We have a new leader at the top of the chain;
We're looking for hope and expecting a change.
There's only so much one man can do;
It will take the American spirit to pull us through.

Cheese-Chicken-and-Rice Casserole

1 (10 3/4-ounce) can cream of chicken soup
1 1/3 cups water
3/4 cup uncooked long-grain white rice
1/2 teaspoon onion powder
2 cups frozen vegetables
4 skinless, boneless chicken breast halves
salt and pepper to taste
1/2 cup shredded cheddar cheese

Use cooking spray to coat 8-by-12-inch, shallow baking dish.

Combine soup, water, rice, onion powder, and frozen vegetables in dish.

Top with chicken, season with salt and pepper (to taste), and cover with foil.

Bake at 375 degrees F for 40–45 minutes; top should be golden brown when done.

Remove from oven; top with cheese.

Wait on the Lord, be of good courage, and He shall strengthen your heart; wait, I say, on the Lord!

—Psalm 28:14

Six Stars in the Window

There were six stars in the window of this old house, you see—
Six sons from Texas who were sent overseas.
Grown-up men, the brothers were sent off to war,
Defending our country and protecting our shores.

Some of the brothers stormed the Normandy beach;
Others were on a ship and would never claim defeat.
One served as a pilot, protecting us from the air;
Uncertainty of survival was more than they could bear.

These brothers all survived World War II;
Returning home to their roots was all they wanted to do.
Six stars in the window had returned safely home;
All went on to raise families of their own.

So thank the veterans when you see them,
Because these six brothers fought for freedom.
And don't forget the fallen comrades,
Because one of these brothers was my dad.

Ruth's Squash Casserole

6–8 medium-size squash, cooked and drained
2 eggs
1 stick margarine, melted
1 can cream of chicken soup
1 small jar Cheez Whiz
6 slices toast, cubed
1 can green chilies

Combine all ingredients in large baking dish.

Bake at 350 degrees F for approximately 30 minutes.

"You have heard that it was said, 'You shall love your neighbor and hate your enemy.' But I say to you, love our enemies, bless those who curse you, do good to those who hate you, and pray for those who spitefully use you and persecute you. That you may be sons of your Father in heaven; for he makes His sun rise on the evil and on the good, and sends rain on the just and on the unjust. For if you love those who love you, what rewards have you? Do not even the tax collectors do the same? And if you greet your brethren only, what do you do more than others? Do not even the tax collectors do so? Therefore you shall be perfect, just as your Father in heaven is perfect."

—Matthew 5:43–48

Living in the Sixties

My mom is watching *As the World Turns*;
The newscaster breaks in and tells us Kennedy is gone.
Listening and watching ever so quietly,
Our hearts are breaking as people fall to their knees.

His motorcade was going through downtown Dallas;
He died by the hand of someone's hatred and malice.
He fought for the American people's freedom and justice,
But where was the justice when he was taken so abruptly from us?

One man was arrested for this horrible deed,
But many were involved in this dreadful scheme.
This president who fought for so many rights—
The next thing you knew, Vietnam was a fight.

As Kennedy was gone and put to rest,
Johnson was sworn in as the next president.
As Johnson was quoted, "I'll give you your war;
Make me president, and I'll settle the score."

The war broke out, and it was a horrible thing;
Many soldiers lost their lives to a world that turned mean.
A peacekeeping mission was what it was supposed to be,
But where was the peace? What should we believe?

I'm a grown adult now, looking back on that time;
The day Kennedy was assassinated will always stay in my mind.
The people responsible for doing this heinous crime,
Will stand before God when it's their time

Cabbage-Patch Stew

2 tablespoons oil or shortening
1 medium-size cabbage
1 pound ground chuck
1 large onion, chopped
1 bell pepper, chopped
2 ribs celery, chopped
2 (16-ounce or larger) cans tomatoes
1 (16-ounce) can ranch-style beans
1 teaspoon chili powder
dash jalapeño pepper
salt and pepper to taste

Heat oil or shortening in large roaster pan.

Chop cabbage and set aside.

Brown ground chuck, onion, bell pepper, and celery together in pan. Add tomatoes, beans, chopped cabbage, chili powder, and jalapeño, and salt and pepper.

Cook on medium-low heat for 30–45 minutes, or until cabbage is tender.

"These things I have spoken to you, that My joy may remain in you, and that your joy may be full."

—John 15:11

Her Life

There is a lady of great blessings,
Who has lived a long, full life.
She was married for many years,
And was a wonderful wife.

She was a member of the garden club,
A painter, and a pianist too;
Tickling the ivories to make beautiful music
Was her favorite thing to do.

The pictures she painted were of beautiful things—
Houses and fields and landscape themes.
Her pictures were even shown in a museum,
God's gift of beauty for all to see them.

For Sophie has touched all of our lives;
She'll never be forgotten as we go through life.
A friend, an aunt, and sometimes a mother—
She will live in our hearts like no other.

Sweet Potato Casserole

Sweet Potato Mixture
1 (23-ounce) can sweet potatoes, drained and mashed
1/2 cup sugar
1/3 cup butter
1 tablespoon vanilla
2 eggs, beaten
1/2 can evaporated milk

Combine above ingredients; whip with fork or spoon.

Pour mixture into large baking dish.

Topping
1/2 cup margarine, melted
1 cup brown sugar
1 cup chopped pecans
1 cup shredded coconut

Combine topping ingredients in mixing bowl.

Spread topping mixture on top of sweet potato mixture.

Bake at 350 degrees F for 30–40 minutes.

"I must work the works of Him who sent Me while it is day; the night is coming when no one can work. As long as I am in the world, I am the light of the world."

—John 9:4–5

His Life

This is a poem about a very wise man,
Who was born in Kaufman, Texas.
He worked the farm and plowed the land,
Along with his family, the Smith clan.

He was working toward an education;
SMU would be his destination.
He graduated with honors and was called off to war,
Defending our country and protecting our shores.

After the war he came home to his wife;
Ready to work and begin a new life.
He succeeded in business as he stood proud and tall;
His love and generosity was a blessing to us all.

We pay you this tribute as you look from above;
We know you watch over us with your kindness and love.
Harold, you have been an inspiration to us all;
You'll live in our hearts, winter, spring, summer, and fall.

Peach Cobbler

1 cup flour
1 teaspoon baking powder
1 cup sweetened condensed milk
1 stick margarine
2 (14-ounce) cans peaches
1 cup sugar

Sift flour and baking powder in mixing bowl. Add sweetened condensed milk; mix well.

Place margarine in bottom of 9-by-12-inch pan; pour batter over margarine.

Heat fruit in saucepan; add sugar (to taste; at least 1/2 cup).

Pour hot fruit on top of batter.

Bake at 375 degrees F for approximately 35 minutes.

Tip: This recipe is also good with apples; substitute an amount of sliced apples equivalent to the canned peaches.

"As the Father loved Me, I also have loved you; abide in My love. If you keep My commandments, you will abide in My love, just as I have kept My Father's commandments and abide in His love."

—John 15:9–10

Sixty Years

In 1949, we said "I do";
A very stunning bride and a handsome groom.
Not much money when we first started out;
But so rich in love, and that's what it was all about.

We walked life's highway and did so much;
Never apart, so we could always touch.
A family was made, a gift from above;
God's blessing for obedience for having true love.

As the years go by, with silver through our hair,
Our love is still like fireworks going off in the air,
Shiny and sparkling and still anew;
We each still smile when the other walks into the room.

This our anniversary of sixty years;
We have laughed a lot and shed some tears.
We stood by each other, side by side;
With memories to hold on to for the rest of our lives.

[AUTHOR'S NOTE: *This poem was written in 2009.*]

Swedish Pineapple Cake

Cake
2 cups granulated sugar
1 (20-ounce) can crushed pineapple, with juice
1 teaspoon baking soda
1 teaspoon vanilla
2 cups flour
1 cup chopped nuts

Combine above ingredients; mix by hand.

Pour into ungreased, unfloured, 13-by-9-by-2-inch baking dish.

Bake at 350 degrees F for approximately 30 minutes, or until done. Use toothpick to check center of cake for doneness.

Frosting
1 (8-ounce) package cream cheese, softened
1 stick margarine, softened
3/4 cup granulated sugar
1 cup chopped nuts

Combine frosting ingredients; mix well.

As soon as cake is taken out of oven, apply frosting.

Set frosted cake aside to cool and then store in refrigerator.

Providing honorable things, not only in the sight of the Lord, but also in the sight of men. And we have sent with them our brother whom we have often proved diligent in many things, but now much more diligent because of the great confidence which we have in you.

—2 Corinthians 8:21–22

Birthday Boy

Happy birthday to the boy who is now a man;
You have grown into such a handsome lad.
In my photo album, I found this picture of you;
What a sweet little boy, one who just turned two.

You now have so many grandchildren,
And some are still on the way.
You have been blessed from above;
What else can anyone say?

So happy birthday to you,
And so many more.
You deserve everything in life,
And so much more.

Chocolate Halfway Cookie Cake

1 cup shortening
1/2 cup white sugar
1 1/2 cup packed brown sugar, divided
2 egg yolks
2 cups flour, sifted
1 teaspoon vanilla flavoring
1/4 teaspoon salt
1 tablespoon water
6 ounces semisweet chocolate chips
2 egg whites

Grease bottom and sides of 9-by-12-inch baking pan.

Cream shortening, sugar, and 1/2 cup brown sugar. Add egg yolks one at a time; mix well. Add vanilla, salt, and water. Add flour, a little at a time. Mix by hand (do not use mixer); batter will be thick.

Spread batter in greased pan. Add chocolate chips; spread evenly.

Beat 2 eggs whites stiff; stir in 1 cup brown sugar. Spread mixture over chocolate chips.

Bake at 375 degrees F for 25–30 minutes. (If glass pan, bake at 350 degrees F.) Use toothpick to check center of cake for doneness.

Cool cake in pan. Cut cooled cake into squares.

"By this My Father is glorified, that you bear much fruit, so you will be My disciples."

—John 15:8

Triplets

Triplets were born on a hot August day,
All three were special in their own unique way.
Sadie, Avery, and Macie, each so very sweet;
The first letters of their names spelled *Sam,* for their father, you see.

Misti was their mother and carried them for nine months,
But when they were born, she did nothing but rejoice.
For Sam and Misti had been given a gift:
Life in abundance that made a family fit.

Three little girls so special and sweet,
Will grow to young ladies and dream big dreams.
With Sam and Misti by their side,
God above them to help them fly.

So bless this family as they live their life,
Walk with them, Lord, and hold their hands ever so tight.
For life is precious, and each day is a gift;
This family of five certainly knows this.

Peanut Butter Crisp

1 cup corn syrup
1 cup powdered sugar
1 cup peanut butter
5 cups Rice Krispies cereal

Combine corn syrup, sugar, and peanut butter in large saucepan. Simmer over low heat. Stir constantly, until hot and melted. Remove from heat. Add cereal; mix well.

Spread in sheath cake pan, and cool. Cut cooled crisp into squares.

Jesus said to her, "I am the resurrection and the life. He who believes in Me, though he may die, he shall live. And whoever lives and believes in Me shall never die. Do you believe this?"

She said to Him, "Yes, Lord, I believe that, You are the Christ, the son of God, who is to come into the world."

—John 11:25–27

An Angel Watching Over Me

I remember waking up one cold December morning,
To the sound of someone who was moaning.
It was my mother who was very sick, you see;
She was crying from her horrible disease.

As I lay awake in my bed, wondering what was going on,
I thought someone was having a bad dream, that's all.
Little did I know as a young child of eight,
The world I knew was gone in one take.

My mother was taken at a very young age;
Her suffering was eased, and there was no more pain.
As she looks down from heaven and watches us all,
I know God needed her for his will and his call.

As I go through my life and try to do what is right,
My mother is with me and always at my side.
A beautiful angel with wings of gold,
Holding my hand and never letting me feel alone.

Uncooked Banana Pudding

2 (8 1/2-ounce) packages instant vanilla pudding mix
2 cups milk
1 can sweetened condensed milk
8 ounces sour cream
4 1/2 ounces Cool Whip (reserve some for top of pudding)
1 teaspoon vanilla
6 medium-size bananas, sliced thin
1 (12-ounce) box vanilla wafers (approximately 1/2 box needed; reserve some wafers to crush on top of pudding)

Using electric mixer, beat pudding mix with milk until smooth. Add sweetened condensed milk, sour cream, Cool Whip, and vanilla; beat until smooth.

In large serving dish, layer pudding, banana slices, and 1/2 box vanilla wafers.

Top with remaining Cool Whip and some crushed vanilla wafers.

Keep refrigerated. Discard after 3 days.

Now godliness with contentment is great gain.

—1 Timothy 6:6

But you, O man of God, pursue righteousness, godliness, faith, love, patience, gentleness.

—1 Timothy 6:11

The Gentle Man

There is a gentle man,
Who goes by the name of Stan.
He took a little girl into his home,
And made her feel like she was his very own.

He never spanked or raised his hand,
Nor did you ever hear a bad word from that man.
But when you messed up and you heard his tone,
You knew you'd better leave that man alone.

He taught me how to drive; every weekend we would go,
With my foot to the floor, and him holding on.
He taught me to work hard, and to pray every day;
And to give thanks to God for all the blessings that came my way.

He is and always will be the gentle man;
Standing tall and proud, and willing to give a hand.
Thank you, Lord, for blessing me with this gentle man,
Because without him, I don't know where I would stand.

Hash Brown Casserole

1 (28- to 32-ounce) package frozen shredded hash browns
1 stick margarine, softened
1 can cream of mushroom soup
1 teaspoon salt
8 ounces sour cream
8 ounces grated cheddar cheese

Grease bottom of 9-by-13-inch baking dish.

Thaw hash browns and place in greased dish.

Combine margarine, soup, salt, sour cream, and cheese in mixing bowl. Pour mixture over hash browns. Do not stir in hash browns; mixture will melt and seep into hash browns.

Bake at 350 degrees F for approximately 30 minutes; top should be golden brown when done.

Not lagging in diligence, fervent in spirit, serving the Lord. Rejoicing in hope, patient in tribulation, continuing steadfastly in prayer.

—Romans 12:11–12

All Your Heart

You grew up and knew exactly what you wanted;
You had your eye on the prize from when your life started.
You went into your profession and never batted an eye;
You went for the gold and got a piece of the pie.

Your love for music was your favorite art,
You painted it like a picture and did it with all your heart.
You became a grand director of the music industry;
Your wisdom and knowledge were an inspiration to me.

You gave your students a passion for learning,
With musical instruments that were their yearning.
You nurtured their hearts and their minds as well,
Giving them a path only time would tell.

As your students graduate from their high school days,
Know that you played a part as they go on their way.
Each heart that you touch will come back threefold;
Mr. Coulson was the one who helped pave that road.

Millionaire Pie

1 cup pecans
1 can flaked coconut
1 can sweetened condensed milk
1 cup crushed pineapple, drained
1/4 cup lemon juice
9 ounces Cool Whip
2 graham cracker crust pie shells

Combine pecans and flaked coconut in mixing bowl. Add sweetened condensed milk, crushed pineapple, and lemon juice. Mix by hand. Add Cool Whip.

Pour mixture into pie shells.

Keep refrigerated. Discard after 3 days.

But above all these things put on love, which is the bond of perfection. And let the peace of God rule in your hearts, to which also you were called in one body, and be thankful.

—Colossians 3:14–15

The Special Mom

There was this woman who came into my life;
She loved me and fed me and tucked me in every night.
She was already a mother with experience under her belt,
But there was something about her that I only felt.

She wasn't the most popular when discipline came along,
But you knew when she was done you should have not done wrong.
Her ways were wondrous and her love endures;
You knew you were loved, and that's for sure.

She could put on a feast the likes of which you have never seen;
Whip up a meal like you wouldn't believe.
Have her chores done by the end of the day,
And still have time to kneel down and pray.

She could sing "noel" all through the year;
Even though it wasn't Christmas, she still had good cheer.
Her favorite song is "How Great Thou Art";
She carries that song always in her heart.

As I go older, with children of my own,
This mother was special and never let me feel alone.
Her wisdom and courage were an inspiration to me;
Maybe one day I'll be as wise as she.

Fruit Salad

2 cans chunked pineapple, with juice
1 can mandarin orange slices, drained
1 (8-ounce) jar maraschino cherries, drained
3 medium-size bananas
1 (8 1/2-ounce) package vanilla instant pudding mix

Combine pineapple, oranges, cherries, and bananas in mixing bowl. Add pudding powder. Mix well.

Place in refrigerator. Fruit will thicken after it chills in refrigerator for a while.

Keep refrigerated. Discard after 3 days.

Oh, continue Your loving-kindness to those who know you, and Your righteousness to the upright in heart.

—Psalm 36:10

The Story of Stacy and Aaron

Here's the story of Stacy and Aaron,
Two young lovers soon to be wed.
Stacy has a smile as big as the night,
And Aaron puts Stacy first in his life.

When they met, Aaron was working as security;
Stacy was a receptionist and cheerful as could be.
But then Aaron went and joined the marines;
He made sure he left love notes on Stacy's computer screen.

Now that they have dated for many years,
Their love has stepped up, and so have their careers.
For Stacy is working with children and education;
Head of security was Aaron's destination.

So come March 21, they will be wed.
A dream coming true and a long life ahead.
For they will walk, hand in hand;
Husband and wife, together they will stand.

Holiday Punch

2 (12-ounce) cans frozen orange juice
2 (12-ounce) cans frozen lemonade
2 (4- to 6-ounce) cans pineapple juice
1 cup sugar
6 cups water
2–3 bottles ginger ale

Combine juices, sugar, and water in large bowl. Mix well. Freeze for at least 12–14 hours, or until frozen.

Place frozen mixture in large punch bowl. Pour in ginger ale; allow to become slushy. (Use only enough ginger ale to create a slushy mixture.)

"These things I have spoken to you, that in Me you may have peace. In the world you will have tribulation; but be of good cheer, I have overcome the world."

—John 16:33

609 Greenwood

You lived at this address for many years,
Fighting through sorrow and living with fear.
You had an addiction you couldn't overcome;
You wanted help, you wanted love.

From a small boy, you grew into a man;
Tall and distinguished, you were a handsome lad.
But a troubled heart you just couldn't mend;
Your trouble with alcohol would be your end.

I can still hear your voice; it whispers like the wind—
You are greatly missed: my brother, my friend.
You left your friends and family behind,
To change your address to the one in the sky.

There will only be one of you;
You left us way too soon.
I didn't get to tell you good-bye,
But I know I will see you again, when it is my time.

Vegetable Casserole

1 (16-ounce) package frozen broccoli, cauliflower, and carrots
1 can cream of mushroom soup
1/3 cup sour cream
1/2 can French's onion rings (reserve a few for topping)
4 ounces shredded cheddar cheese (reserve a bit for topping)
salt and pepper to taste

Cook frozen vegetables for approximately 7 minutes; drain.

Combine soup, sour cream, onion rings, cheese, and salt and pepper in large casserole dish.

Combine soup mixture with vegetables; cover, and microwave for 5 minutes; turn dish, and microwave for another 5 minutes.

Place reserved onion rings and cheese on top, and microwave for 5 more minutes; when done, top should be golden brown and cheese should be melted.

For God so loved the world that He gave His only begotten Son, that whoever believes in Him should not perish but have everlasting life.

—John 3:16

"And this is the will of Him who sent Me, that everyone who sees the Son and believes in Him may have everlasting life, and I will raise him up at the last day."

—John 6:40

Sunrise Spin

The game was like ring-around-the-rosy,
But not one person fell down.
Our laughter was our music;
We played it really loud.

We danced in a circle;
It was an early morning dawn.
Holding hands, with smiles
As wide and deep as a yawn.

It was tall golden wheat as we did the sunrise spin,
Spinning around and seeing all of my kin.
Grandparents and parents, aunts and uncles too,
Dancing in a circle was all we wanted to do.

I want you to know that heaven is a spin away;
The "sunrise spin" was the name of our game.
Time did not matter as we danced around,
For we all knew we were homeward bound.

Green Bean Casserole

1 can cream of mushroom soup
3/4 cup milk
1/8 teaspoon pepper
2 cans green beans, drained
1 1/3 cup french-fried onions, divided (2.8-ounce can)

Combine soup, milk, and pepper in 1 1/2-quart casserole dish; mix well. Stir in beans and 2/3 cup french-fried onions.

Bake at 350 degrees F for 30 minutes. Stir; sprinkle with remaining 2/3 cup onion rings. Bake 5 minutes more, or until onions on top are golden.

"Truly, truly I say unto you, whoever hears my word and believes in who sent me has eternal life. He does not come unto judgment, but has passed from death to life."

—John 5:24

My Little Girl

You were born on a hot August day,
A waiting area full of family as your grand entrance was made.
Pretty and sweet and oh so new;
We couldn't wait to show you off like a precious jewel.

As a little girl, you grew into your teens;
Time has flown by with your own hopes and dreams.
As you have grown and had kids of your own,
A circle of life still goes on.

So let me just say to my little girl who's grown,
Your mother loves you more than you will ever know.
Always look to the One above;
He will always bring you the greatest love.

Peanut Butter Fudge

2 pounds powdered sugar
1 stick of margarine
1/4 teaspoon salt
1 large can evaporated milk
1 (7-ounce) jar marshmallow cream
18 ounces chunky peanut butter

Grease a 9-by-13-inch pan.

Combine sugar, margarine, salt, and evaporated milk in medium saucepan. Boil for 17 minutes.

Remove from heat; add marshmallow cream and peanut butter. Stir well, until thoroughly mixed.

Pour mixture into greased pan.

Cool fudge in pan. Cut cooled fudge into pieces as desired.

But these are written so that you may believe that Jesus is the Christ. The son of God. And that by believing you may have life in his name.

—John 20:31

My Son

There's something between a mother and a son;
The first time I ever laid eyes on you, a bond was formed.
As a little boy so mild and sweet,
Every time I was with you, it was such a treat.

As you grew up and became a man,
My little boy was such a handsome lad.
As the sun lights up the sky with a morning kiss,
Seeing you happy is my great bliss.

My love for you, my son, will never end.
For when I am gone, I will see you again.
Keep your eyes on God, and never lose faith,
For I am in your heart and can never be replaced.

Strawberry Bread

1/8 cup margarine
1 1/2 cup sugar
1 teaspoon vanilla
1/2 teaspoon lemon flavoring
4 eggs
1/2 teaspoon baking soda
1/2 cup sour cream
3 cups flour
1/2 cup nuts
1 cup strawberry jam

Combine margarine, sugar, vanilla, and lemon flavoring in large mixing bowl. Add eggs, one at a time; beat well.

Dissolve baking soda in sour cream; add to mixture.

Fold in flour, nuts, and jam.

Bake at 350 degrees F for 40 minutes. Use toothpick to check center of bread for doneness.

www.ingramcontent.com/pod-product-compliance
Lightning Source LLC
Chambersburg PA
CBHW021036180526
45163CB00005B/2154